M000113103

Kawaii Doodle Class

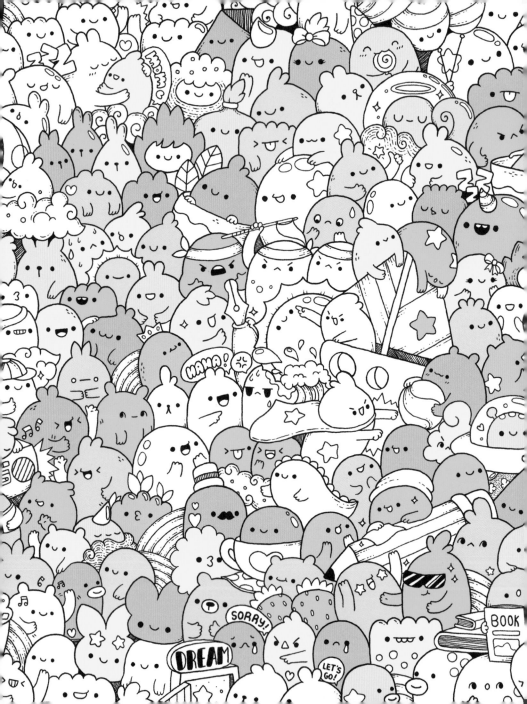

Mini
Kawaii
Doodle Class

SKETCHING SUPER-CUTE TACOS, SUSHI, CLOUDS,
FLOWERS, MONSTERS, COSMETICS, AND MORE

Zainab Khan Creator of

Pic Candle

Race Point
PUBLISHING

Acknowledgments

I want to thank my family and friends for their help and encouragement, everyone who follows me and enjoys my silly random doodles (your support encourages me to draw more doodles!), and Jeannine Dillon and the Race Point Publishing team for the opportunity to make this book.

Brimming with creative inspiration, how-to projects, and useful information to enrich your everyday life, Quarto Knows is a favorite destination for those pursuing their interests and passions. Visit our site and dig deeper with our books into your area of interest: Quarto Creates, Quarto Cooks, Quarto Homes, Quarto Lives, Quarto Drives, Quarto Explores, Quarto Gifts, or Quarto Kids.

First published in 2018 by Race Point Publishing, an imprint of The Quarto Group, 142 West 36th Street, 4th Floor, New York, NY 10018, USA
T (212) 779-4972 **F** (212) 779-6058 **www.QuartoKnows.com**

Race Point Publishing titles are also available at discount for retail, wholesale, promotional, and bulk purchase. For details, contact the Special Sales Manager by email at specialsales@quarto.com or by mail at The Quarto Group, Attn: Special Sales Manager, 401 Second Avenue North, Suite 310, Minneapolis, MN 55401, USA

10 9 8 7 6 5 4 3 2 1

ISBN: 978-1-63106-582-8

Editorial Director: Jeannine Dillon
Creative Director: Merideth Harte
Project Editor: Erin Canning
Cover Design: Merideth Harte
Interior Design: Yeon Kim and Merideth Harte

Printed in China

FSC
www.fsc.org
MIX
Paper from responsible sources
FSC® C017606

Contents

Adorable Food & Drinks 17

Lovable Nature 43

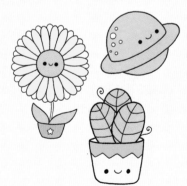

Cheerful Doodle Monsters 69

Everyday Cute 85

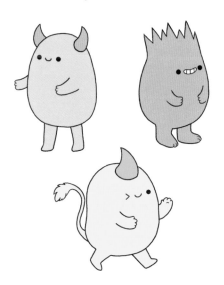

Hi!

My name is Zainab, but you can find my kawaii doodles on the internet under the handle Pic Candle. I recently quit my day job to doodle full time, because I love drawing so much. Crazy, right?!

I approach my doodles randomly without planning or thinking about the end results. I find this process to be very exciting because you never know what's going to happen. It's a surprise! I usually start with a doodle character or object that comes to mind and then keep drawing more characters and decorations, one by one, to fill up the page (see my Search-&-Find Puzzles starting on page 129). While doodling, I focus only on the character or object that I'm drawing, not the big picture.

Regarding coming up with characters, they're mainly inspired by real-life objects and simple shapes (such as a sphere, cube, cylinder, pyramid, and cone) that I have modified or combined. I also like creating make-believe characters (see Cheerful Doodle Monsters starting on page 69).

I hope this book inspires you to develop a love for doodling and creating kawaii characters.

Kawaii Doodle Class is now in session!

What Is Kawaii?

You might have heard the word. You have probably seen the hashtag. You definitely know the style. But what, exactly, does *kawaii* mean?

Kawaii is a Japanese concept or idea, dating back to the 1970s, that translates closely to "cuteness" in English. In Japan, the usage of the word is quite broad and can be used to describe *anything* cute, from clothing and accessories to handwriting and art. So if you are a fan of emoji art or the style of beloved characters like Hello Kitty, Pokémon, or Pusheen the Cat, then you already know and love the kawaii style of art!

While there are many interpretations as to what constitutes the "kawaii" art aesthetic, most people can agree that kawaii art is usually composed of very simple black outlines, pastel colors, and characters or objects with a rounded, youthful appearance. Facial expressions in kawaii art are minimal and characters are frequently drawn with oversized heads and smaller bodies.

In this book, I'll show you how to draw kawaii-inspired art using the things we see every day like food, nature, makeup, and more. The great thing about kawaii culture is that it's not limited to anything, so once you start practicing, you can turn even the most common thing into something kawaii!

How to Use This Book

Kawaii Doodle Class includes five sections (Adorable Food and Drinks, Lovable Nature, Cheerful Doodle Monsters, Everyday Cute, and Charming Holiday Decorations) with more than 75 characters for you to learn how to draw.

Each character is illustrated with simple step-by-step instructions to get you started doodling. Each chapter also includes Get Inspired pages, showing you even more doodle ideas, and Doodle Party pages, where you can practice what you have learned.

At the back of the book is a section called Fun Time! with Search-&-Find Puzzles that you can also color.

Tools

You don't need to invest in many tools to get started doodling kawaii. You can use pen and paper, or you can draw digitally, or you can start with pen and paper and then scan your art in case you want to color it digitally. It's up to you!

BLACK PENS

The pens I use most are fineliner pens as they come in various tip sizes. I prefer to work with 3 tip sizes for varying line widths, though your end results can also be achieved using only one pen. Here are the tip sizes I use:

- thin tip (for tiny details, patterns, and shadows)

- medium-size tip (for main outlining)

- thick tip (for thicker outlining outside of the main outlines—this is to make characters stand out and also for filling in large areas with black)

WHITE PENS

I use these for corrections and adding highlights.

PAPER

I'm not too picky when it comes to the paper I use for doodling. Basic sketchbooks and printer paper work just fine, but if you want to use something more professional, that's a personal preference.

MECHANICAL PENCILS

Since ink is permanent, sketching with pencil before inking is helpful when drawing complex characters. Mechanical pencils are great for drawing lines and the option of varying lead thicknesses is useful.

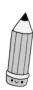
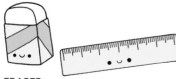

ERASER
A good eraser is always needed for fixing those sketching mistakes. And there are always mistakes!

RULER
Depending on how precise you want to be with your lines and such, it can't hurt to have a ruler on hand.

MARKERS AND/ OR WATERCOLORS (optional)
I like using 1 or 2 colors and adding them only in some areas of my doodles, leaving other areas blank. This "semi-coloring" method works for me because it takes less time to do, and it's also easy and fun. The chances of ruining my doodles are also reduced with semi-coloring. If you want to color your doodles, semi-coloring is a good practice and less intimidating for beginners.

PHOTOSHOP (optional)
When I doodle using pen and ink and then scan the image, I use Photoshop to clean it and prepare a print-ready file. Sometimes, I also like to add colors to hand-drawn doodles digitally with Photoshop. Mixing the traditional and digital processes to create final artwork is also fun!

Tips & Tricks

Being a full-time doodle artist, I want to share the tips and tricks I have learned over time for creating kawaii characters.

- Sketch your characters with a mechanical pencil before inking them, especially more complex characters.

- When drawing square, rectangular, and pointy shapes, rounding corners and points always adds a cuter element to the character.

- Adding a simple face is always recommended, but if you don't have room, no worries. Faceless characters can also be cute!

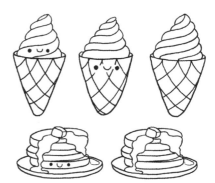

- But if you prefer giving your characters a face, drawing their bodies or faces wider will give you more room to do this.

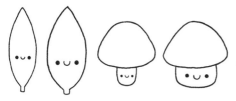

- Speaking of faces, go ahead and play around with the position of the face. You don't have to place the face in the center every time, or ever!

- Varying the distance between a character's eyes and mouth can really change the appearance of a facial expression.

- Drawing a nose, along with eyes and a mouth, can really add "character" to your characters.

- Once you have drawn your characters, feel free to adorn them with decorations (hearts, stars, speech bubbles, etc.) and accessories (hats, sunglasses, bows, etc.) Visit the Doodle & Accessories Directory on page 12 for inspiration!

- Most importantly, there are no right or wrong ways to doodle kawaii characters. Just experiment and try to come up with your own unique style with the help of this book!

Doodle Directory

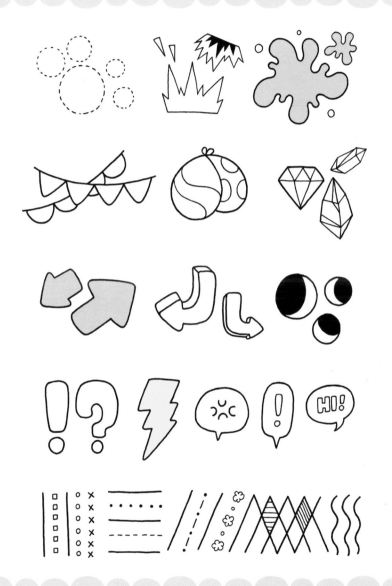

Doodle Accessories

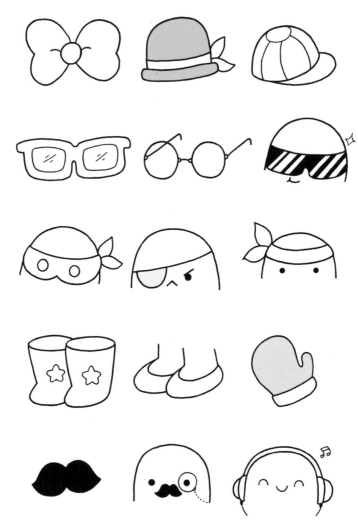

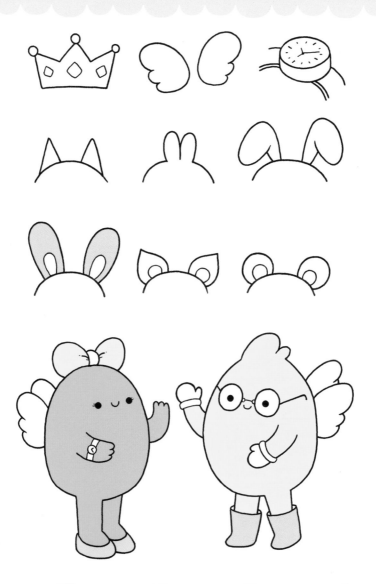

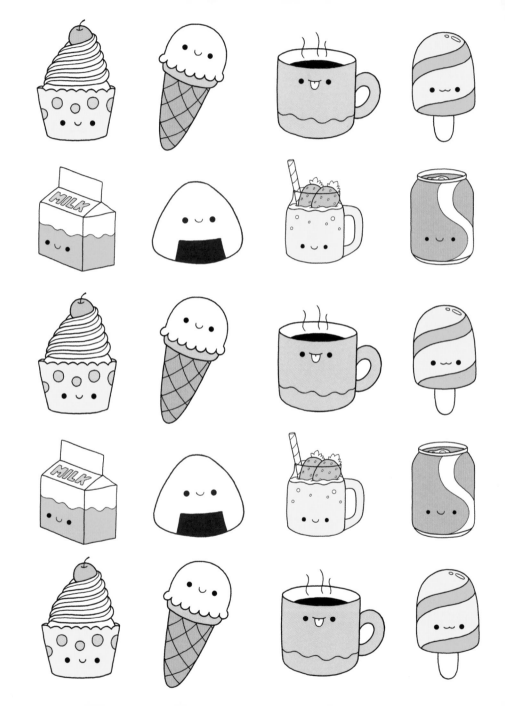

Adorable Food & Drinks

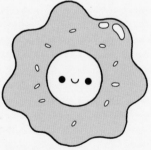

Ice Cream Cone

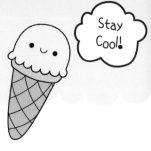

Stay Cool!

1. Draw a semicircle with a scalloped edge.

2. Draw a straight line with 2 curved ends for the top of the cone.

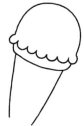

3. Draw 2 slanted lines for the sides of the cone.

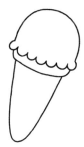

4. Connect the slanted lines with a rounded tip.

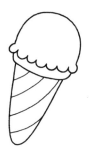

5. Draw 4 curved lines inside the cone, from right to left.

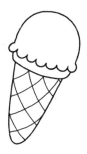

6. Draw 4 more curved lines, from left to right.

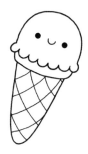

7. Draw a cute face, of course!

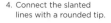

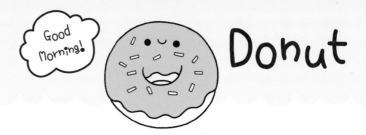

Donut

1. Draw a semicircle, then draw a wavy line for the gooey glaze.

2. Draw in the bottom curve to complete the circle.

3. Draw a smiley mouth in the center of the donut.

4. Draw a small arc in the center of the smiley mouth for the donut's hole.

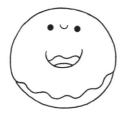

5. A little above the small arc, draw a wavy line for even more gooey glaze. Draw a cute face, of course!

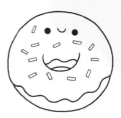

6. Don't forget the sprinkles! Use a fine point pen to draw them.

Cupcake

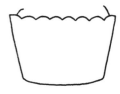

1. Draw a straight line with 2 slanted lines coming up from it.

2. Complete the liner with a pretty scalloped edge.

3. Draw short curved lines in from the edges of the liner.

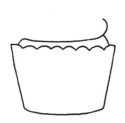

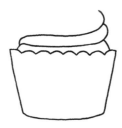

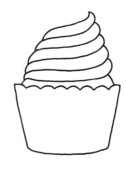

4. Now it's time to draw the swirling frosting! Connect the left curved line to the right one, then swoop up with your pen.

5. Draw another swooping line.

6. Draw 4 more swooping lines. These lines will be a little curvier than the first 2 lines and will get increasingly shorter.

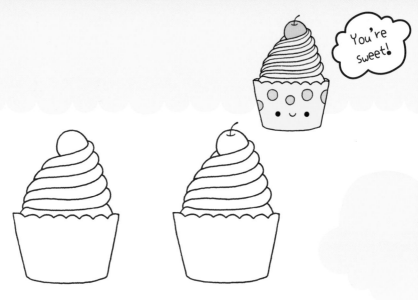

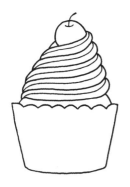

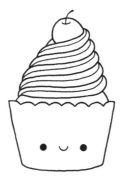

7. Put a cherry on top! Nestle a semicircle into the swoop of the top line.

8. Draw a smiley mouth in the cherry, then draw a cherry stem with a thicker end. Swoop the frosting around the cherry with a short line.

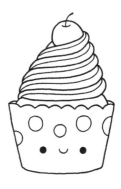

9. Draw 5 inner lines in the frosting using a fine point pen.

10. Draw a cute face, of course!

11. Decorate your cupcake liner with a favorite pattern using a fine point pen. Add sprinkles to the cupcake, if you like!

Hamburger

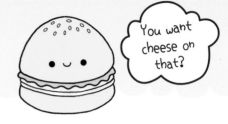

You want cheese on that?

1. Draw a fat triangle with rounded points for the top of the bun.

2. Draw a wavy line for the lettuce.

3. Below the lettuce, draw 2 parallel, curving lines.

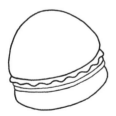

4. Draw a straight line with 2 curved edges for the bottom of the bun.

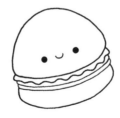

5. Draw a cute face, of course!

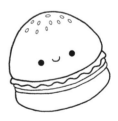

6. Top the bun with some sesame seeds using a fine point pen.

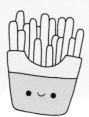

French Fries

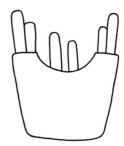

1. Draw a semicircle with 2 slanted lines, kind of like drawing the shoulders and a neckline of a shirt.

2. Draw 2 slanted lines for the sides of the box. Connect these lines, making rounded corners.

3. Start drawing your French fries! Some can be tall and others short.

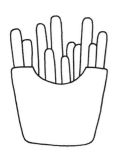

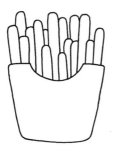

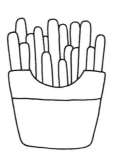

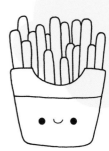

4. Make sure you have fries in the front and the back, filling in any space.

5. Draw even more French fries! You can't have enough French fries!

6. Draw a straight line across the box. Add decoration to your box, if you like!

7. Draw a cute face, of course!

Popsicle

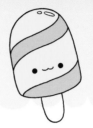

Brrrrr!

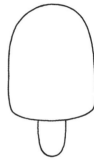

1. Draw an upside-down U shape.

2. Close the U shape, making rounded corners.

3. Draw a much smaller U shape for the stick.

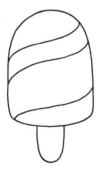

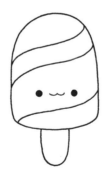

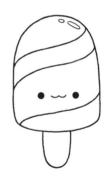

4. Draw 3 curved lines, from left to right for texture.

5. Draw a cute face, of course!

6. Draw 2 small ovals on the top of the Popsicle with a fine point pen to add some shine.

Tally ho!

Sticky Toffee Pudding

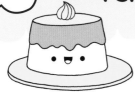

1. Draw 2 slanted lines from the sides of an incomplete oval. Connect these lines with a wavy line.

2. Draw 2 more slanted lines.

3. Connect these slanted lines, making rounded corners.

4. Add a dollop of clotted cream. At the opening in your oval, draw 5 curving lines that meet at a point.

5. Draw an oval around the base of the pudding for a plate.

6. Draw another oval parallel to the first one to give the plate an edge.

7. Draw a cute face, of course! Add fruit or decoration to your sticky toffee pudding, if you like!

Fried Egg

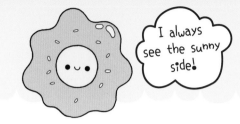

1. Draw a circle.

2. Draw a wavy outline around the yolk, kind of like an amoeba.

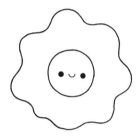

3. Draw a cute face, of course!

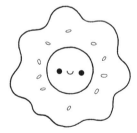

4. Season your egg with some salt! Use a fine point pen to do this.

5. Draw 2 small ovals on the top right with a fine point pen to add some shine.

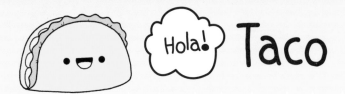

Taco

1. Draw a semicircle with a little swoop on the left edge. Connect the edges, making the left corner pointy and the right corner rounded.

2. Draw a wavy line for the lettuce.

3. Draw a curved line for the back of the shell.

4. Stuff your taco with more goodies by drawing 4 scallops on the left side.

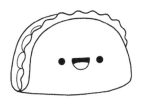

5. Draw a cute face, of course! Try drawing the face at different positions to see how the character looks.

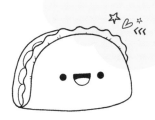

6. Draw line details using a fine point pen. Add decoration to your taco, such as stars, hearts, and other doodle elements, if you like!

Hot Dog

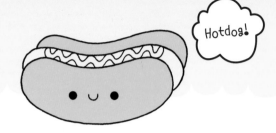

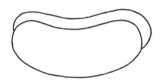

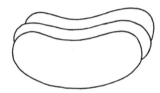

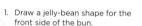

1. Draw a jelly-bean shape for the front side of the bun.

2. Draw a line that runs parallel to this line, for the hot dog.

3. Repeat step 2 for the back side of the bun.

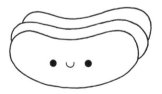

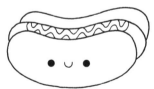

4. Draw a cute face, of course!

5. Do you prefer ketchup or mustard?! Draw 2 parallel zigzag lines for your topping. Add decoration to your hot dog, if you like!

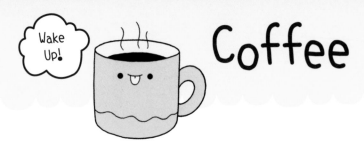

Coffee

1. Draw an oval.

2. Draw 2 straight lines from the sides of the oval. Connect them, making rounded corners.

3. Draw an ear shape for the handle.

4. Draw a smaller, parallel ear shape

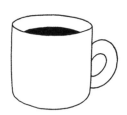

5. Draw a semicircle inside the mug, then fill it in for the coffee.

6. Draw a cute face, of course!

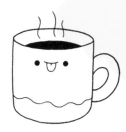

7. Draw some steam lines. Also, decorate your mug! I drew a wavy line across mine, but make yours special to you.

Sushi

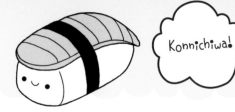

Konnichiwa!

1. Draw a teardrop or paisley shape.

2. Draw a curved, inner line with a fine point pen.

3. Draw an oblong U shape for the rice.

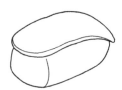

4. Draw a curved vertical line on the right front of the rice.

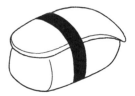

5. Draw 2 curved, vertical parallel lines for the seaweed, then fill in the space in between them.

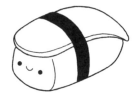

6. Draw a cute face, of course!

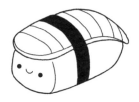

7. Use a fine point pen to add details to the sushi.

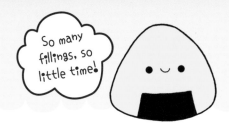

So many fillings, so little time!

Onigiri

1. Draw a fat triangle with rounded points for the rice ball.

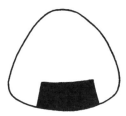

2. Draw a trapezoid for the seaweed and fill it in.

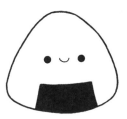

3. Draw a cute face, of course!

Strawberry Smoothie

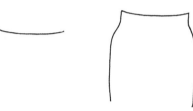 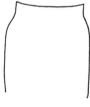 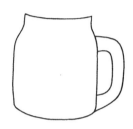

1. Draw a smiley mouth that's barely smiling.

2. From the edges, draw lines that curve in and then straighten out.

3. Connect the sides, making rounded corners.

4. Draw an ear shape for the handle, then draw a smaller, parallel ear shape.

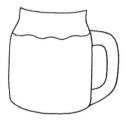 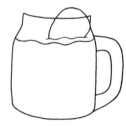 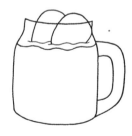

5. Draw a wavy line a little below the curve in the jar for the liquid.

6. Draw an upside-down U shape with a shorter right side for a strawberry. Close the U shape with a wavy line

7. Add another strawberry to the left of the first one.

8. Add stems and seeds to the strawberries with a fine point pen.

9. Draw 2 long parallel lines connected at the top with a small oval for the straw.

10. Draw some stripes on the straw.

11. Draw some bubbles in the smoothie with a fine point pen.

12. Draw a cute face, of course!

Milk

Moo!

 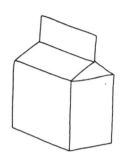

1. We want to give our carton a 3-D look, so start by drawing a square at an angle.

2. Draw 2 parallel lines from the right side, about half the length of your square's sides. Connect these lines.

3. Draw 4 lines as if you were adding a roof to a house.

4. Draw a 3-sided rectangle for the top of the carton.

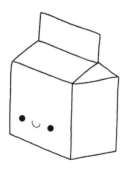 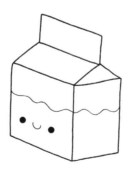 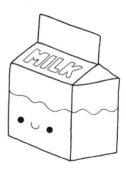

5. Draw a cute face, of course!

6. Decorate your box! I added a wavy line.

7. Letter with the word "milk," if you like!

Loaf of Bread

1. Draw an incomplete oval.

2. Draw the sides and base of the bread, making it curvy with rounded corners.

3. Draw a line that mimics the shape of your bread. Connect the bases of the 2 bread shapes.

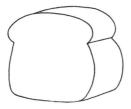

4. Draw a horizontal line where the loaf curves in.

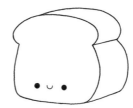

5. Draw a cute face, of course! Try drawing the face at different positions to see how the character looks.

Swiss Cheese

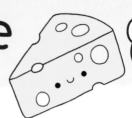

Yodelay hee hoo!

1. Draw a slightly curved line.

2. From the top of this line, draw a line at an angle, with a dip about halfway down.

3. Draw a third line to complete the triangle. Leave a space to draw a small oval and make sure the points are rounded.

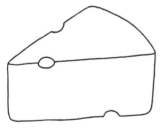

4. Draw a 3-sided rectangle for the wedge's side, making a "hole" in the base. Keep those corners rounded!

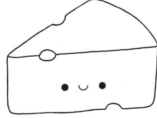

5. Draw a cute face, of course!

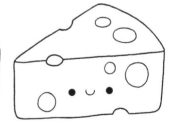

6. This wedge of cheese isn't Swiss enough, so add some more holes!

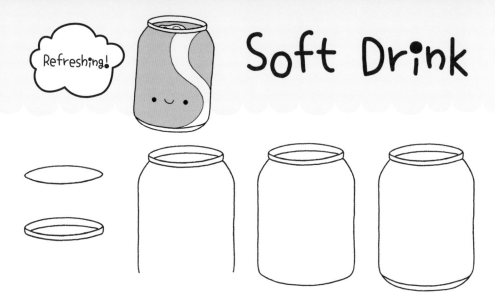

Refreshing!

Soft Drink

1. Draw an oval, then draw 2 curved lines that run parallel to your oval.

2. From the sides of the oval, draw 2 slanted lines that straighten out.

3. Connect the sides, making rounded corners.

4. Draw a curved line for the base of the can.

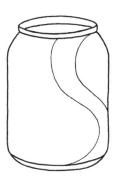

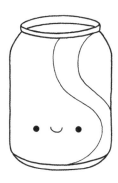

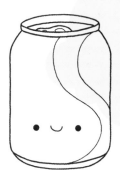

5. Decorate your can! I drew a swoosh pattern.

6. Draw a cute face, of course!

7. Don't forget the pop top! Draw a curvy line, then draw 2 semi-circles inside for the holes.

Get Inspired

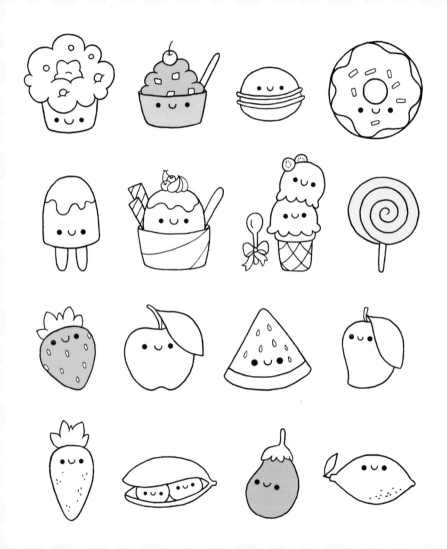

Here are some more of my kawaii food and drink doodles to inspire you. Check out their fun facial expressions and decorations! Hungry yet?

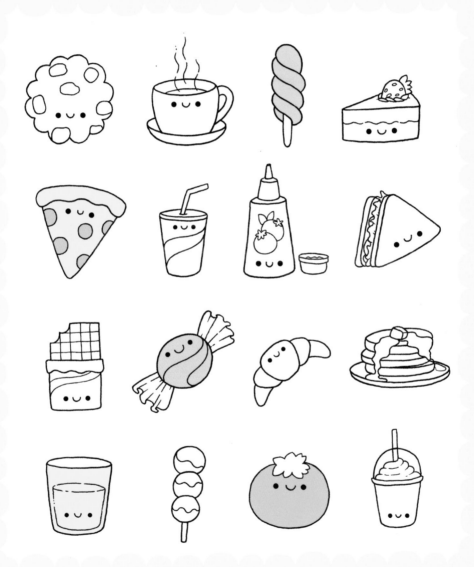

Doodle Party

Kawaii Doodle Class is over for today, so it's time to practice what you've learned. Use these pages to draw the food and drinks having a party. Don't forget to consult the Doodle Directory & Accessories on page 12!

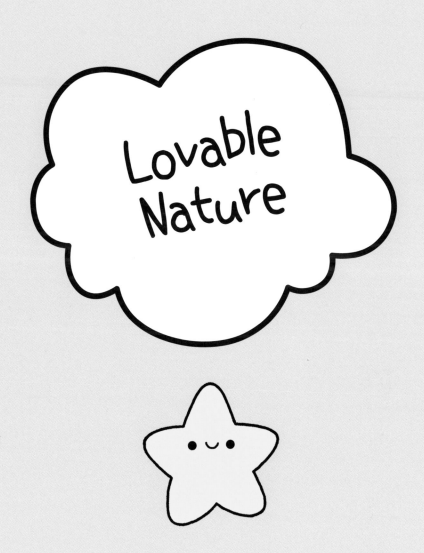

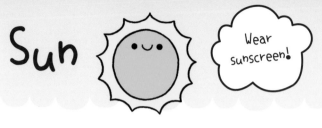

VERSION 1

 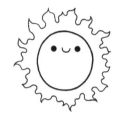

1. Draw a circle.

2. Draw curvy lines of varying lengths that meet with a sharp point.

3. Continue drawing rays entirely around the circle.

4. Draw a cute face, of course!

VERSION 2

 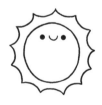

1. Draw a circle.

2. Draw a smiley mouth.

3. Continue drawing smiley mouths as if drawing waves in water.

4. Draw a cute face, of course!

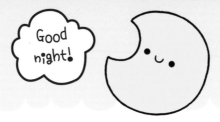

Moon

1. Draw an incomplete circle.

2. Fill in the opening with a semicircle.

3. Draw a cute face, of course!

 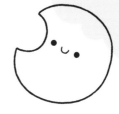

1. Draw a semicircle.

2. Draw an incomplete circle from the ends of the semicircle.

3. Draw a cute face, of course!

Star

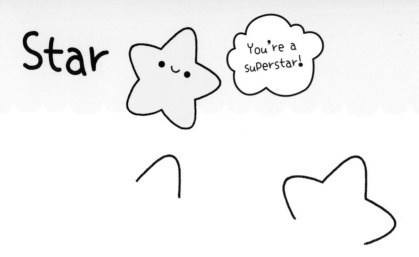

1. Draw an upside-down V shape with a rounded point at an angle.

2. Add 2 "arms" to the star, making the V shapes a little fatter.

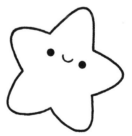

3. Add the "legs" to the star with even bigger V shapes.

4. Draw a cute face, of course! Try drawing the face at different positions to see how the character looks.

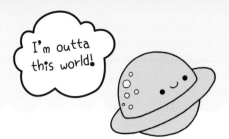

Planet

1. Draw a semicircle at an angle.

2. Close the semicircle, making rounded corners.

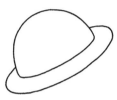

3. Draw an oval-shaped ring around the planet.

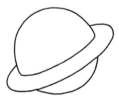

4. Draw an arc beneath the ring to complete the planet.

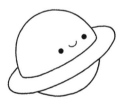

5. Draw a cute face, of course! Try drawing the face at different positions to see how the character looks.

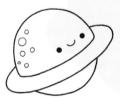

6. Add some craters by drawing small circles with a fine point pen.

Cloud

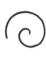

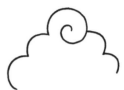

I'm floating! Whee!

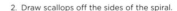

1. Draw a spiral or curlicue.

2. Draw scallops off the sides of the spiral.

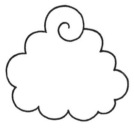

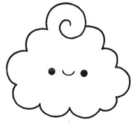

3. Continue drawing scallops of varying sizes to complete the cloud shape.

4. Draw a cute face, of course! Add decoration to your cloud, such as stars, hearts, and other doodle elements, if you like.

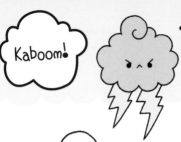

Thundercloud

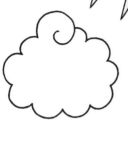

1. Follow steps 1 to 3 for Cloud on page 48.

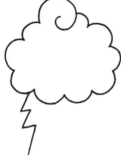

2. Draw a zigzag line coming from the cloud.

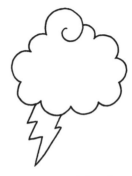

3. Draw a second zigzag line meeting the first line with a point.

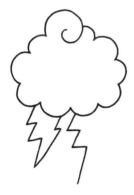

4. Draw a second lightning bolt, starting with a zigzag line.

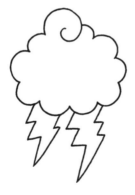

5. Complete the second lightning bolt.

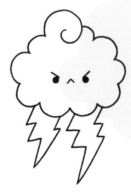

6. Draw an angry face (though it still looks kind of cute)!

Rainbow

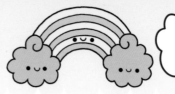

I'm all about color!

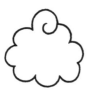 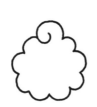

1. Draw 2 clouds following steps 1 to 3 for Cloud on page 48.

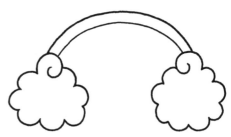

2. Draw a large arc to connect the clouds. Draw a smaller arc below the first arc.

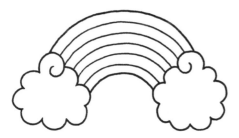

3. Draw 5 more arcs, getting increasingly smaller in size. Try to evenly space your arcs.

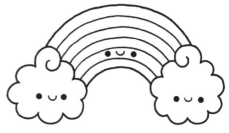

4. Draw cute faces, of course, on the clouds and the rainbow!

Tree

1. Draw a fluffy cloudlike shape with the bottom wider than the top.

2. Draw concave lines for the trunk.

3. Draw a cute face, of course!

4. Draw some grass around the base of the trunk.

5. Decorate your tree! I drew some round fruit.

Daisy

Spring has sprung!

1. Draw a circle.

2. Surround the circle with petals.

3. Draw a second layer of petals by drawing small arcs in between the existing petals.

4. Draw a cute face, of course!

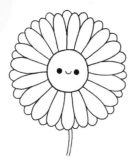

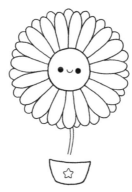

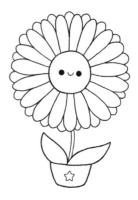

5. Draw the stem.

6. Draw an upside-down trapezoid for the flowerpot, making rounded corners. Decorate your flowerpot! I drew a star.

7. Draw 2 leaves to fill in the space between the stem and the flowerpot.

 Hallo! 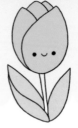 Tulip

1. Draw an incomplete oval.

2. Draw a curved line in the oval to make a petal.

3. Draw a short line from the top of the left side of the oval.

4. Draw an arc in the center of the flower.

5. Draw a smaller arc to the right of the center arc.

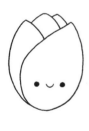 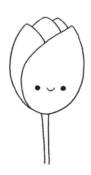 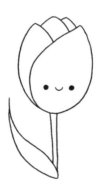 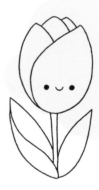

6. Draw a cute face, of course!

7. Draw the stem.

8. Draw a leaf with a pointy tip.

9. Draw 2 more leaves.

Rose

1. Draw a small oval with an amoeba shape around it. Connect them with a short line and a tiny loop.

2. Draw short lines off the amoeba's sides. Surround this shape with a messy heart shape.

3. Draw a tiny loop off the line on the right side, then draw a line that runs down the right side of the heart shape.

4. Draw more lines within the heart shape to represent a closed bud.

 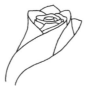 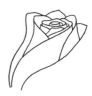

5. Draw 4 lines off the right side of the heart shape.

6. Draw an arc between the petals, then draw a concave line off the left petal.

7. Draw a short line off the right petal, then draw a long, curving line, catching the lines on the right side of the flower.

8. Draw a line off the left petal that runs parallel to the left side of the flower.

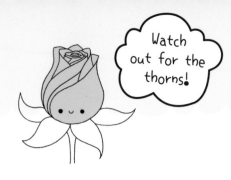

Watch out for the thorns!

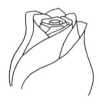

9. Draw a line off the right side of the flower that curves and gives a wide shape to your rose.

10. Round out the bottom of the rosebud.

11. Draw one more curving line in the center.

12. Draw a cute face, of course!

13. Draw four leaves with pointy tips at the base of the rosebud.

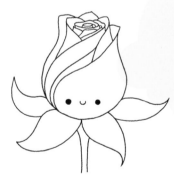

14. Draw the stem.

Leaf

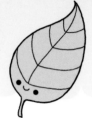

I fall for you!

1. Draw a curvy line as if you are drawing one side of a teardrop or paisley.

2. Draw a curved line off the first line. Make sure the tip is pointy and leave an opening at the bottom for the stem.

3. Draw the stem.

4. Draw a line down the center of the leaf, about three-quarters of its length.

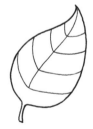

5. Draw 4 wide V shapes for the veins. Try to space them evenly apart.

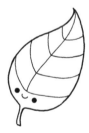

6. Draw a cute face, of course!

Four-Leaf Clover

I'm lucky!

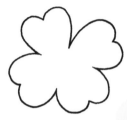

1. Draw 2 connecting heart shapes, leaving their bottoms open.

2. Draw 2 more connecting heart shapes to complete the clover.

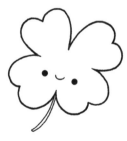

3. Draw a delicate stem using a fine point pen.

4. Draw a cute face, of course!

Little Bud

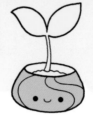

Yoohoo!

1. Draw an incomplete oval.

2. Draw slanted lines from the sides of the oval, then connect them with a line, making rounded corners.

3. Draw the stem using a fine point pen.

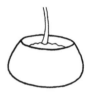

4. Draw a scraggly arc inside the pot for the dirt.

5. Draw 2 connected leaves coming off the top of the stem.

6. Draw a cute face, of course!

7. Decorate your pot! I drew 3 curving lines.

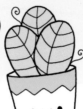

Potted Plant

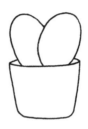

1. Draw an incomplete oval.

2. Draw slanted lines from the sides of the oval, then connect them, making rounded corners.

3. Draw an oval-shaped leaf.

4. Draw another leaf off the first one.

5. Draw an arc between the 2 leaves.

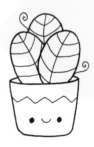

6. Using a fine point pen, draw the veins. Draw a line down the center of each leaf and then add large V shapes to each one. Try to space them evenly apart.

7. Add some decorative elements to your plant. I drew some tendrils!

8. Draw a cute face, of course!

9. Decorate your pot! I drew a zigzag line.

Succulent

1. Draw an incomplete oval.

2. Draw curved lines from the sides of the oval.

3. Draw an oval around the base of the teacup.

4. Draw a large smiley mouth from the sides of this oval for the saucer's base.

5. Draw an ear shape for the handle, then draw a smaller, parallel ear shape.

6. Draw 4 upside-down V-shaped leaves of varying heights.

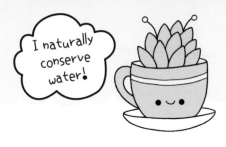

7. Draw a second layer of leaves between the first layer.

8. Draw a third layer of leaves.

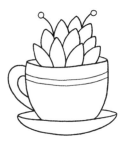

9. Decorate your plant and teacup! I added some antennae-looking elements to my plant and a large stripe to my teacup.

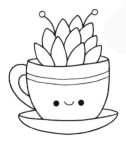

10. Draw a cute face, of course!

Cactus

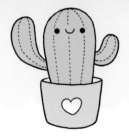

Don't mind my prickly nature!

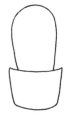
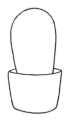
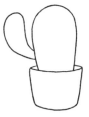

1. Draw a smiley mouth, that's barely smiling.

2. Draw slanted lines from the sides of the mouth, then connect them, making rounded corners.

3. Draw an upside-down U shape for the cactus.

4. Draw small, curved lines around the sides of the cactus at the top of the pot.

5. Draw an "arm" off the left side of the cactus.

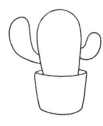
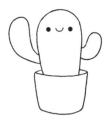
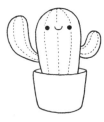
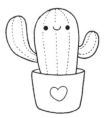

6. Draw another "arm." Make this "arm" a different size than the first one for added cuteness.

7. Draw a cute face, of course!

8. Draw dashes and/or dots with a fine point pen for some prickly texture.

9. Decorate your pot! I drew a heart.

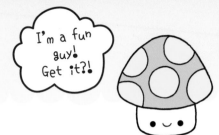

Mushroom

1. Draw a fat triangle with rounded points.

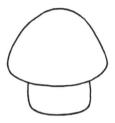

2. Draw a wide stem so you can add a face. Make sure the corners are rounded!

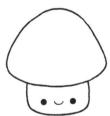

3. Draw a cute face, of course!

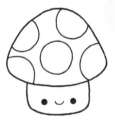

4. Decorate your mushroom! I drew circles and semicircles.

Get Inspired

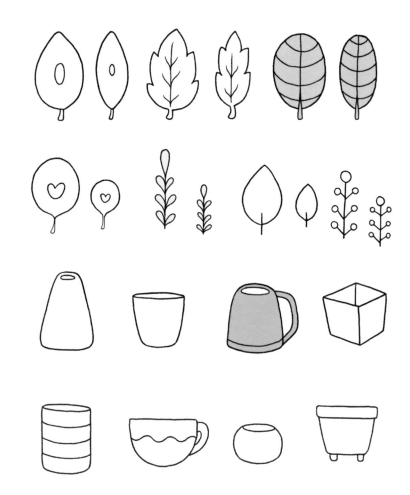

Here are some more of my kawaii nature doodles. Check out the fun shapes and different styles of planters!

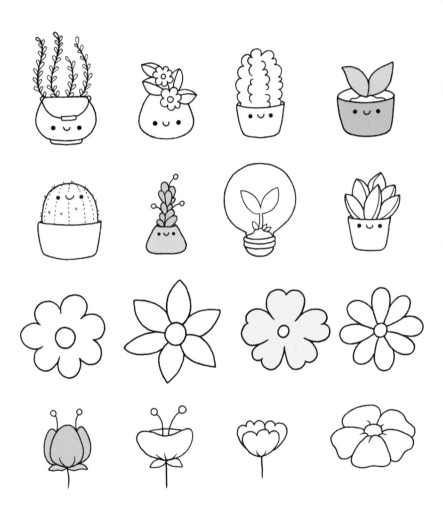

Doodle Party

Kawaii Doodle Class is over for today, so it's time to practice what you've learned. Use these pages to draw the nature elements having a party. Don't forget to consult the Doodle Directory & Accessories on page 12!

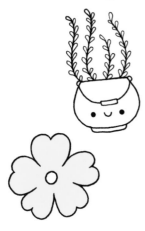

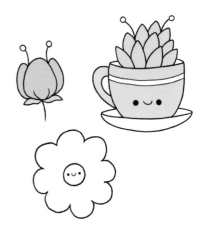

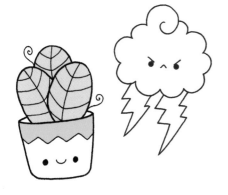

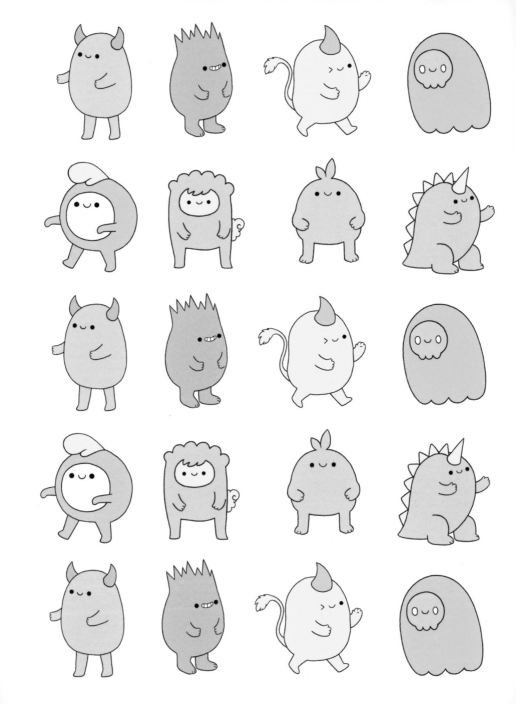

Cheerful
Doodle
Monsters

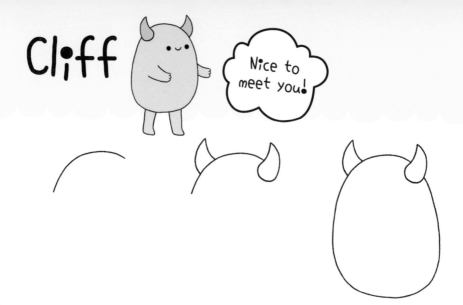

Cliff

Nice to meet you!

1. Draw a curved line.

2. Draw 2 pointy horns. My horns are devilish!

3. Draw an egg shape for the body.

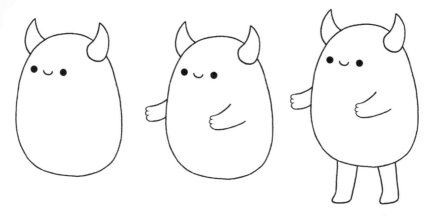

4. Draw a cute face, of course!

5. Draw the arms and hands, with fingers.

6. Draw the legs and feet in proportion to your arms and hands.

1. Draw some pointy spikes of varying lengths to form the width of the head.

2. Draw an oval shape for the body, leaving an opening for a leg.

3. Draw a leg and foot in the opening. Add some toes.

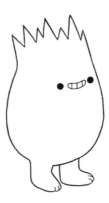

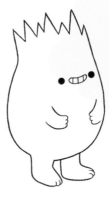

4. Draw another leg, foot, and toes.

5. Draw a cute face, of course! I gave him some teeth.

6. Draw the arms and hands, with fingers, in proportion to your legs and feet.

Kiki

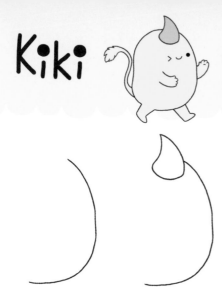

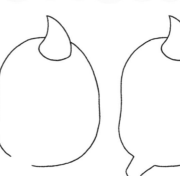

Wink wink!

1. Draw a line that resembles half of an egg shape.

2. Draw a horn. Mine resembles the tip of a soft-serve ice cream cone!

3. Draw a line with a slight curve, for the back. Leave an opening for a leg.

4. Draw the legs and feet.

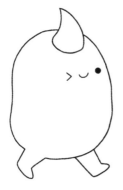

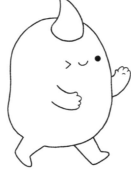

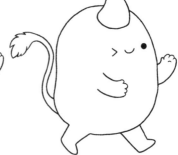

5. Draw a cute face, of course! I drew an arrow for a wink.

6. Draw the arms and hands, with fingers, in proportion to the legs and feet.

7. Draw a tail. My tail was inspired by a lion's tail. Roar!

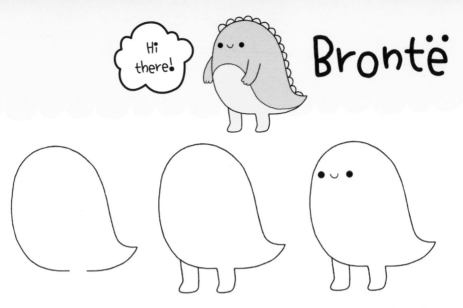

Hi there!

Bronte

1. Draw an oblong shape with a pointy tail. Leave an opening for a leg.

2. Draw the legs and feet.

3. Draw a cute face, of course!

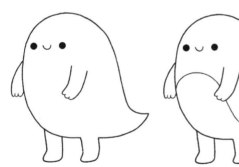
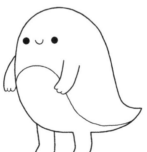

4. Draw the arms and hands, with fingers, in proportion to your legs and feet.

5. Draw a curved line to distinguish the belly.

6. Draw rounded scales down the monster's back.

Cheerful Doodle Monsters 73

1. Draw an upside-down U shape with the ends curving to the left.

2. Draw a scalloped edge, making sure the scallops curve to the left to show movement.

3. Draw a cute face, of course!

4. Draw some simple arms and hands.

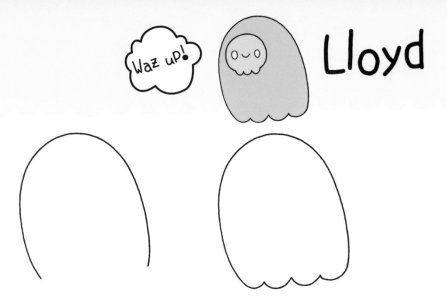

1. Draw an upside-down U shape at an angle.

2. Draw a scalloped edge.

3. Within the body, draw an incomplete circle with a scalloped edge.

4. Draw a cute face, of course!

Cheerful Doodle Monsters 75

Dolly

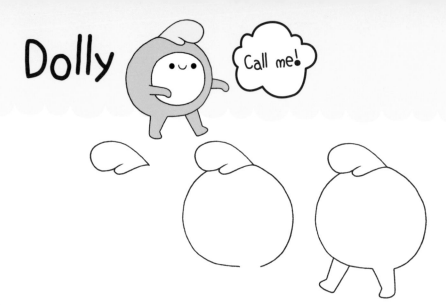

Call me!

1. Draw an oblong upside-down heart shape.

2. Draw a circle, leaving an opening for a leg.

3. Draw the legs and feet.

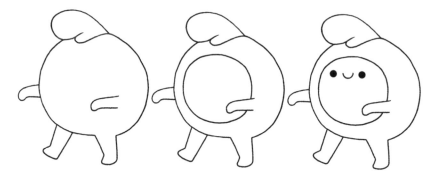

4. Draw the arms and hands in proportion to your legs and feet.

5. Draw a circle within the body. Do not draw a line through the right arm.

6. Draw a cute face, of course!

 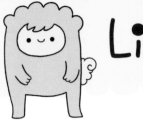

Linda

1. Draw an arc with a scalloped edge to form the width of the head.

2. Draw slightly curving lines for the sides of the body.

3. Draw the legs and feet and connect them with a slightly curved line.

4. Draw a few small scallops for bangs. Draw them toward the left to give a sideswept look!

 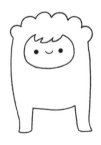

5. Draw an oblong circle from the edges of the bangs for the face.

6. Draw a cute face, of course!

7. Draw the arms and hands, with fingers.

8. Draw a tail off her right side. I made my tail extra swirly!

Randall

Hugs!

1. Draw 2 connecting leaf shapes.

2. Draw 2 curved lines off the leaves.

3. Draw the arms and hands, with fingers, curving the elbows out a bit.

4. Draw 2 short, curved lines below the arms, a little way in from the elbows.

5. Draw the legs and feet, with toes, in proportion to your arms and hands. Connect the legs with a slightly curved line.

6. Draw a cute face, of course!

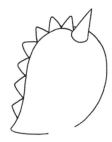

1. Draw a horn with a pointy tip and rounded base at an angle.

2. Draw a curvy L shape for the back, with a pointy tail.

3. Draw rounded-triangular scales down the monster's back.

4. Draw a curved line for the front of the body, leaving an opening for a leg.

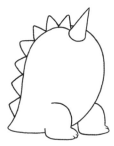

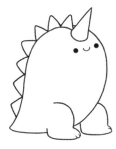

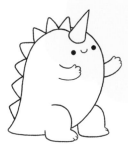

5. Draw the chubby legs and feet, adding toes.

6. Draw a cute face, of course!

7. Draw the arms and hands, with fingers. His arms and legs aren't proportional because he is part tyrannosaur!

Get Inspired

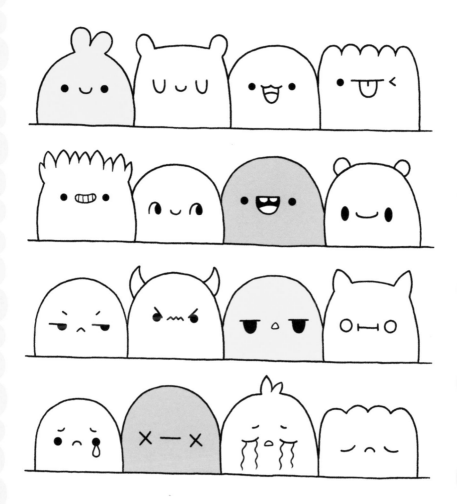

Here are some more of my kawaii monster doodles to inspire you. Check out their fun facial expressions and accessories!

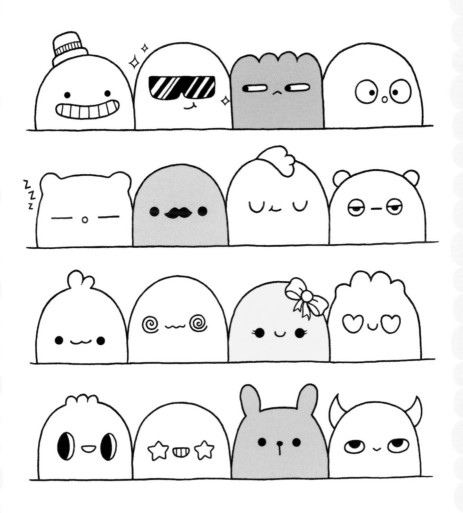

Doodle Party

Kawaii Doodle Class is over for today, so it's time to practice what you've learned. Use these pages to draw the monsters having a party. Don't forget to consult the Doodle Directory & Accessories on page 12!

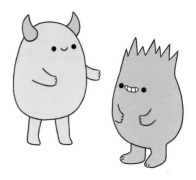

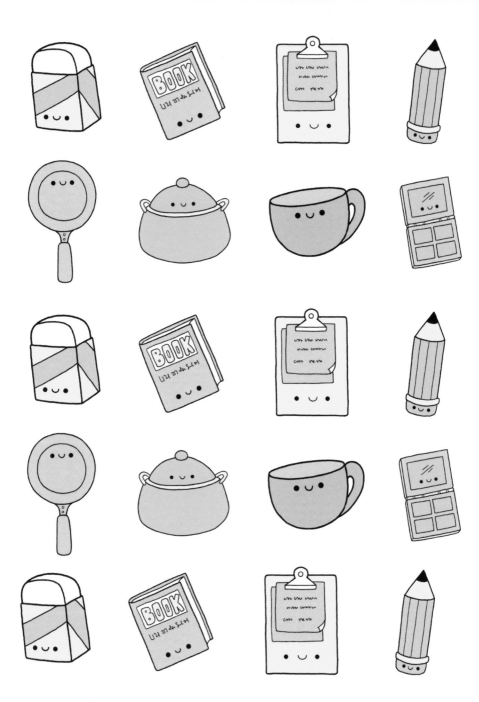

Everyday
Cute

Pencil

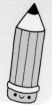

I make a good Point!

 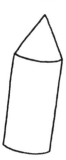 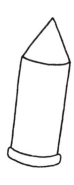 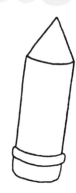

1. Draw an upside down V shape.

2. Draw straight lines from the edges of the V shape.

3. Draw a slightly curved line to connect the sides.

4. Draw a curved line parallel to the one in step 3, then connect them.

5. Draw a 3-sided rectangle with. rounded corners.

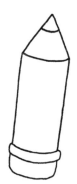 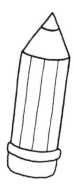 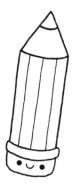 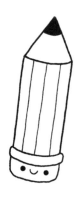

6. Draw a slightly curved line at the tip for the lead.

7. Decorate the body of your pencil using a fine point pen! I drew 3 vertical lines.

8. Draw a cute face, of course! You can place the face in the point, if you like!

9. Fill in the lead tip.

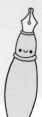

I need some ink!

Fountain Pen

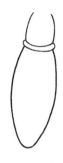

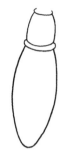

1. Draw 2 curved lines.

2. Connect these lines with a slightly curved line. Draw a second horizontal line, then connect them.

3. Draw 2 long, curved lines for the pen's body. Connect the ends with a rounded tip.

4. Draw an incomplete oval at the top of the pen.

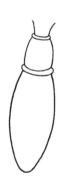

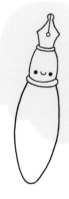

5. Draw another smaller oval, then draw concave lines off its sides.

6. Draw 2 more concave lines off the ones in step 5, then close the nib with a rounded point.

7. Draw a line with a small circle at its end, halfway down the nib.

8. Draw a cute face, of course! Try drawing the face at different places on the pen.

Eraser

Mistakes! are cool!

1. We want to give our eraser a 3-D look, so start by drawing a square at an angle.

2. Draw 2 parallel lines from the right side, half the length of your square's sides, then connect these lines.

3. Draw an arc.

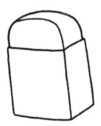

4. Draw another arc.

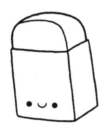

5. Draw a cute face, of course!

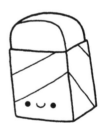

6. Decorate your eraser! I drew wide diagonal stripes.

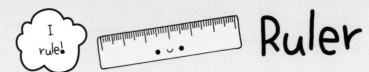

Ruler

1. Draw 2 parallel lines at an angle with 4 short rounded edges.

2. Connect the edges.

3. Draw lines for the centimeter marks. Evenly space them apart.

4. Draw half-centimeter marks. These should be half the length of the centimeter marks.

5. Draw millimeter marks. These should be half the length of the half-centimeter marks.

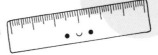

6. Draw a cute face, of course!

Book

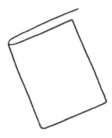

1. Draw a narrow U shape with a longer top line at an angle.

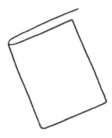

2. Draw a 3-sided rectangle off the bottom line, making the bottom-left corner rounded.

3. Draw 4 lines for the block of pages.

4. Draw a straight line to complete the back cover, then connect it with the page block.

5. Draw a cute face, of course!

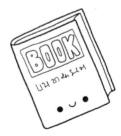

6. Decorate your book with some text and/or a design!

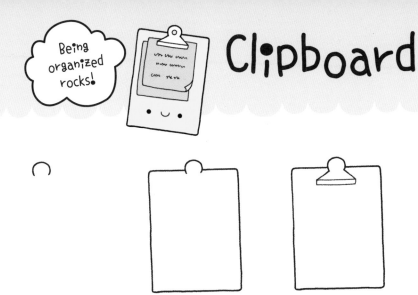

Clipboard

Being organized rocks!

1. Draw a small semicircle.

2. Draw a rectangle with rounded corners from the sides of the semicircle.

3. Draw slanted lines off the ends of the semicircle and connect them with a narrow rectangle.

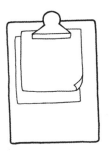

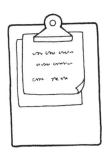

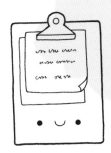

4. Add pages to the clipboard.

5. Add some details to your pages with a fine point pen.

6. Draw a cute face, of course!

Spoon

 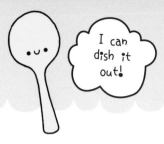

I can dish it out!

1. Draw an incomplete circle.

2. Draw short concave lines from the ends of the circle.

3. Draw slanted lines for the sides of the handle.

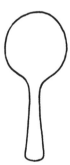

4. Connect the sides, making rounded corners.

5. Draw a cute face, of course!

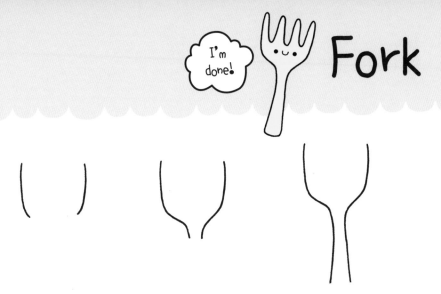

Fork

1. Draw 2 slightly curved lines, kind of like parentheses.

2. Draw short concave lines from the ends of these lines.

3. Draw slanted lines for the sides of the handle.

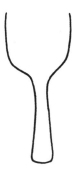

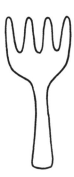

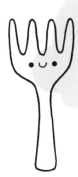

4. Connect the sides, making rounded corners.

5. Draw 4 tines with rounded points.

6. Draw a cute face, of course!

Knife

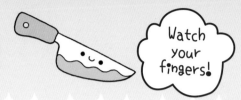

Watch your fingers!

1. Draw a straight line at a slight angle.

2. Draw a curved line, about three-quarters the length of the first line.

3. Complete the blade by drawing a line that curves inward and down.

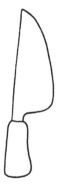

4. Draw the handle, making rounded corners

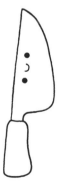

5. Draw a cute face, of course!

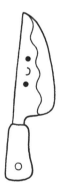

6. Using a fine point pen, draw a hole in the handle and a wavy line along the blade.

 Frying Pan

1. Draw a circle.

2. Draw a smaller circle within the circle using a pen with a finer point.

3. Draw concave lines for the top of the handle.

4. Draw a rectangle with rounded corners for the handle.

5. Draw a cute face, of course!

6. Draw 2 screws using a fine point pen.

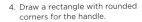

Cooking Pot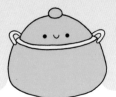

1. Draw a small oval.

2. Draw curving lines from the sides of the oval.

3. Draw a slightly curved line to connect the sides.

4. Draw a line that runs parallel to the curved line from step 3.

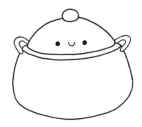

5. Draw the sides and base of the pot, making rounded corners. Leave openings for the handles.

6. Using the openings as a guide, draw curved lines with inner, parallel curved lines for the handles.

7. Draw a cute face, of course!

1. Draw an oval at an angle.

2. Connect the sides of the oval with an arc.

3. Draw an ear shape for the handle, then draw a smaller, parallel ear shape.

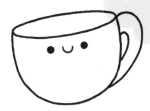

4. Draw a cute face, of course! Add some tea and steam to your teacup, if you like! See Coffee on page 29.

Water Bottle

1. Draw a small oval, then draw a 3-sided rectangle off the oval for the cap, making rounded corners.

2. Starting in from the cap's sides, draw short, straight lines that become slanted lines.

3. Draw the sides of the bottle. Smooth the edges from the slanted to straight lines.

4. Connect the sides, making rounded corners.

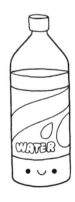

5. Draw an oval about a quarter of the way down the bottle to show the water level.

6. Draw curved lines for the top and bottom of the label.

7. Draw a cute face, of course!

8. Decorate the label of your bottle with text and/or a design! I drew water droplets and a diagonal swoosh.

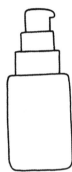

1. Draw a large rectangle with rounded corners.

2. Draw 2 smaller 3-sided rectangles on top of the large rectangle.

3. Draw the pump top with a rounded corner on the top left and a curved edge on the top right.

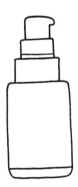

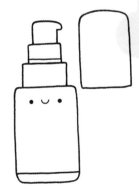

4. Draw a line to define the bottle base, then draw a shorter line in the rectangle below the pump.

5. Draw a cute face, of course! Add a cap for the bottle, if you like!

Lipstick

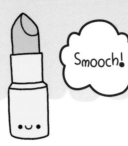

Smooch!

1. Draw an upside-down V shape with extended sides.

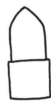

2. Draw a rectangle or square off the V shape.

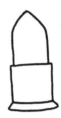

3. Draw short, slanted lines from the sides of the rectangle/square, then connect these lines with a curved line.

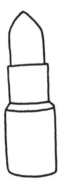

4. Draw a 3-sided rectangle, making rounded corners.

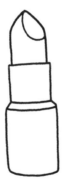

5. Draw a semicircle at the tip of the lipstick for the indent.

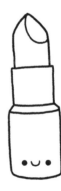

6. Draw a cute face, of course! Decorate your lipstick holder, if you like!

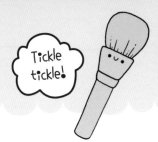

Makeup Brush

1. Draw an upside-down trapezoid at an angle.

2. Draw a 3-sided rectangle off the base, making rounded corners.

3. Draw long lines from the sides of the rectangle. Connect them, making rounded corners.

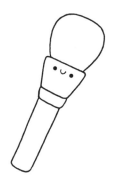

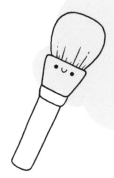

4. Draw a fat upside-down U shape for the brush head.

5. Draw a cute face, of course!

6. Draw some lines of varying length in the brush head with a fine point pen, to give it texture. Decorate your brush handle, if you like!

Eye Shadow

 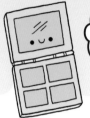

Ooh la la!

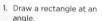

1. Draw a rectangle at an angle.

2. Draw a line beneath the rectangle. Connect the line to the rectangle with a curved line on the right and a small circle on the left.

3. Draw a second rectangle that is equal in size to your first rectangle.

4. To give the compact a 3-D look, draw a line along the left sides of the rectangles and the base. Connect these lines to the rectangles at the corners.

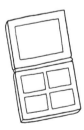

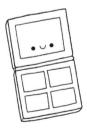

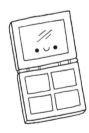

5. Draw a smaller rectangle within the top rectangle for the mirror. Draw 4 small rectangles of equal size in the bottom rectangle for the palette.

6. Draw a cute face, of course!

7. With a fine point pen, add 4 pairs of curved lines for hinges and draw lines for the mirror's shine.

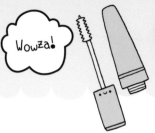

Mascara

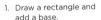
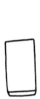
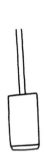

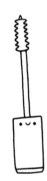

1. Draw a rectangle and add a base.

2. Draw long, straight lines for the wand.

3. Draw squiggly lines for the brush.

4. Connect the squiggly lines with a slightly curved line and top with a small point. Draw a cute face, of course!

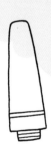

5. To draw the cap, start with long, slanted lines, connecting them with a curved line on top and a straight line on bottom.

6. Draw a 3-sided rectangle off the base.

7. Draw 2 horizontal lines within this rectangle with a fine point pen.

8. Decorate your cap! I drew thin stripes.

Nail Polish

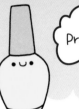

Pretty!

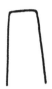

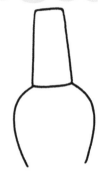

1. Draw slanted lines, then connect them at the top.

2. Connect them with a a curved line at the bottom.

3. Draw curved lines from the sides of the cap for the bottle.

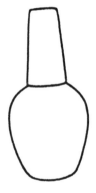

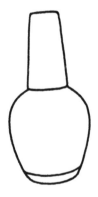

4. Connect these curved lines by rounding out the base.

5. Draw a curved line above the base to give the bottle some heft.

6. Draw a cute face, of course!

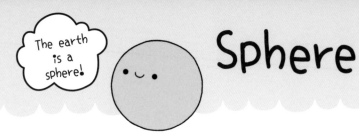

Sphere

1. Draw a circle.

2. Draw a cute face, of course!

Cylinder

Find me in the oatmeal aisle!

1. Draw an oval.

2. Draw straight lines from the sides of the oval.

3. Give the straight lines curved ends.

4. Connect the sides with a curved line.

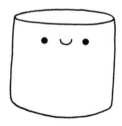

5. Draw a cute face, of course!

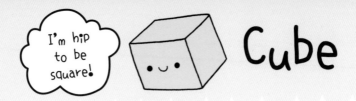

I'm hip to be square!

Cube

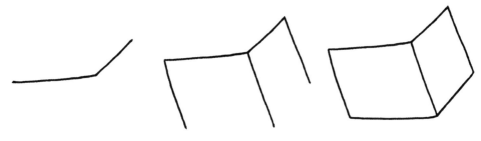

1. Draw a horizontal line, then draw a shorter line at an angle off the right side of this line.

2. Draw 3 parallel lines.

3. Connect the parallel lines.

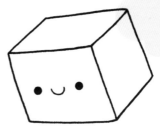

4. Close the cube with 2 lines on top.

5. Draw a cute face, of course!

Pyramid

Have you visited Egypt?

1. Draw an upside-down V shape at a slight angle.

2. Draw an angled line off the point of the V shape.

3. Complete the shape by joining the sides.

4. Draw a cute face, of course!

1. Draw an oval at an angle

2. Draw lines slanting inward from the sides of the oval.

3. Connect these lines with a rounded point.

4. Draw a cute face, of course!

Get Inspired

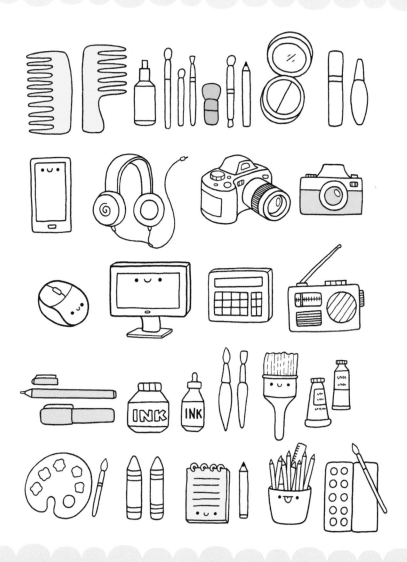

Here are some more of my kawaii everyday object doodles. Check out all the cute stuff you can draw!

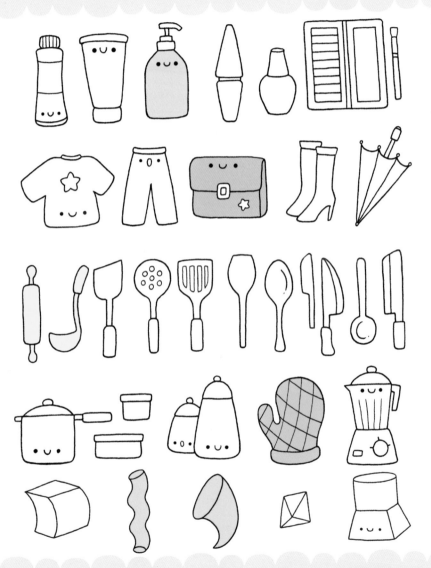

Doodle Party

Kawaii Doodle Class is over for today, so it's time to practice what you've learned. Use these pages to draw the everyday objects having a party. Don't forget to consult the Doodle Directory & Accessories on page 12!

Heart

1. Draw the top of a heart shape.

2. Draw arms and hands, with fingers, with elbows curving out a bit.

3. Draw the base of the heart with a rounded point.

4. Draw a cute face, of course! Add decoration to your heart, if you like!

1. Draw a 3-sided rectangle at an angle.

2. Connect the sides of the rectangle with a wide V shape with a rounded point.

3. Draw another wide V-shape off the base of the envelope.

4. Draw 2 slanted lines for the envelope's folds.

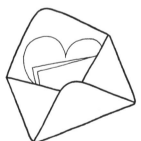

5. Draw surprises inside your envelope! I drew a heart and a folded note.

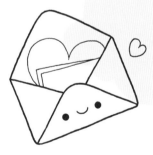

6. Draw a cute face, of course! Decorate your envelope, if you like!

Easter Egg

Find me!

1. Draw an egg shape.

2. Draw a cute face, of course! Try drawing the face at different positions to see how the character looks.

3. Decorate your egg! I decorated my egg with a wide swoop, stars, and ovals.

Pumpkin spice it up!

PumPkin

1. Draw a round shape with lines slightly curving in at the top. Leave an opening for the stem.

2. Draw an oval in the center of the pumpkin.

3. Draw a curved line off each side of the oval.

4. Draw the stem. Connect the sides with a small circle.

5. Draw a leaf.

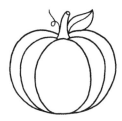

6. Give the leaf a center vein and draw a tendril.

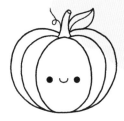

7. Draw a cute or scary face, if you dare!

Witch's Potion

1. Draw an incomplete oval.

2. Draw lines that slant inward from the sides of the oval.

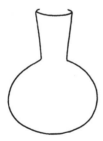

3. Give the bottle a rounded bottom.

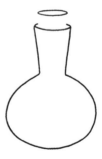

4. Draw a small oval above the neck of the bottle for the top of the cork.

5. Draw a curved line inside the top of the bottle. Connect it to the oval above.

6. Complete the cork by drawing a 3-sided rectangle with rounded corners.

7. With a fine point pen, draw an oval using dots and long dashes to give the look of liquid.

8. Draw an arc, using the dot/dash technique from step 7. Leave some space between the liquid and bottle to give the glass some heft.

9. Draw a cute face, of course!

10. Draw bubbles of varying sizes using a fine point pen.

Skull

Happy Halloween!

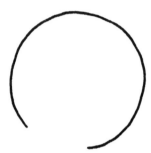

1. Draw an incomplete circle at an angle.

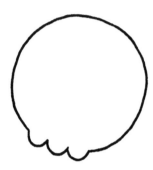

2. Close the circle with a scalloped edge.

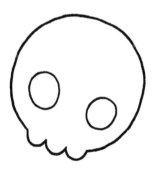

3. Draw some large, hollow eyes, kind of like alien eyes.

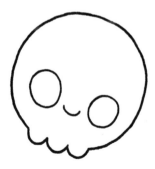

4. Draw a smiley mouth, or you can draw a nose instead.

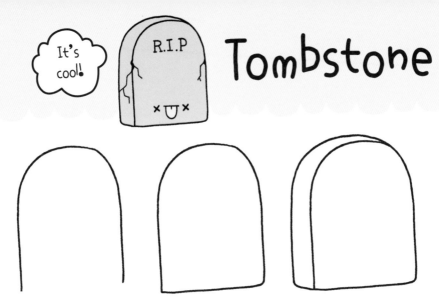

It's cool!

Tombstone

1. Draw an upside-down U shape.

2. Close the U shape with a straight line and a rounded right corner.

3. Draw a curved line for the back of the tombstone. Connect the front and back sides.

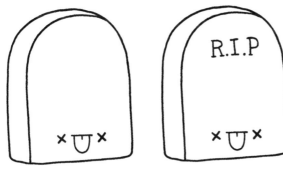

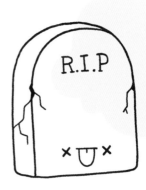

4. Draw small Xs for the eyes and a tongue hanging out.

5. Write the word "R.I.P" on the tombstone.

6. Draw some cracks with a fine point pen.

Christmas Stocking

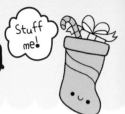
Stuff me!

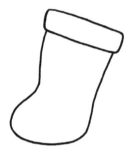

1. Draw a horseshoe shape for the foot of the stocking.

2. Draw a concave line from each side of your horseshoe. The left line should indent more than the right.

3. Connect the sides of the stocking with a rectangle, making rounded corners.

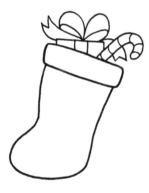

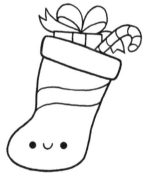

4. Fill the stocking with goodies! I drew a candy cane and a wrapped present.

5. Decorate your stocking! I added a swoosh. Draw a cute face, of course!

124 Kawaii Doodle Class

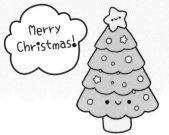

Merry Christmas!

Christmas Tree

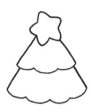
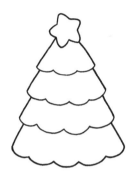

1. Draw a cute star! See Star on page 46.

2. Draw the first, smallest layer using slanted lines. Connect these lines with a shallow scalloped edge.

3. For the next tree layer, repeat step 2, making this layer wider.

4. Add 2 more layers to complete your tree.

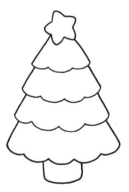
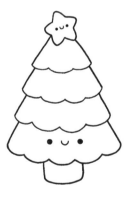
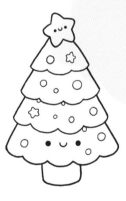

5. Draw a three-sided rectangle for the trunk, making rounded corners.

6. Draw a cute face on the star and the tree! You can place the face on the trunk, if you like.

7. Decorate your tree using a fine point pen! I drew stars and circles.

Doodle Party

Kawaii Doodle Class is over for today, so it's time to practice what you've learned. Use these pages to draw the holiday decorations having a party. Don't forget to consult the Doodle Directory & Accessories on page 12!

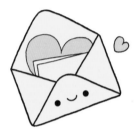

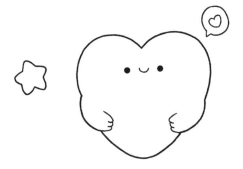

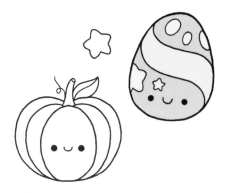

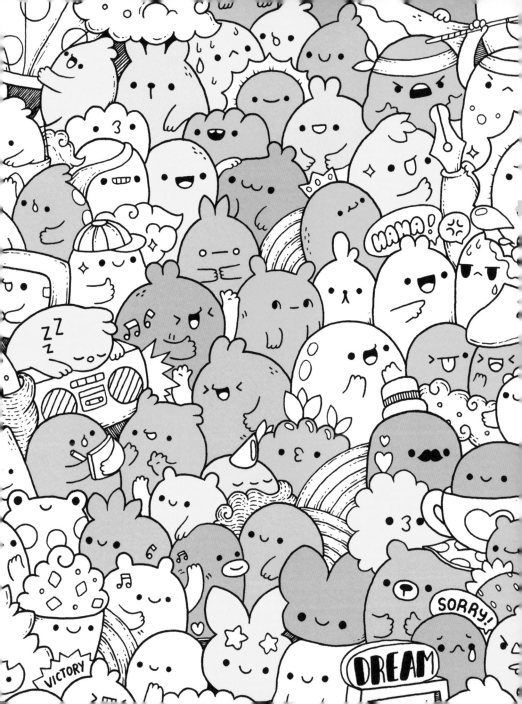

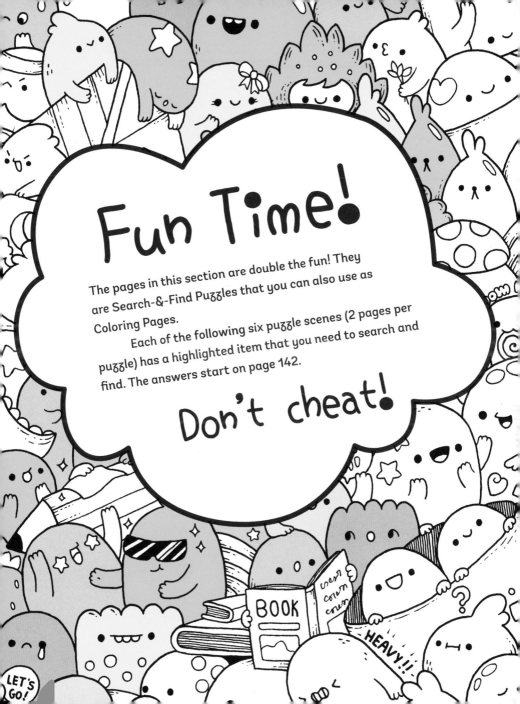

Fun Time!

The pages in this section are double the fun! They are Search-&-Find Puzzles that you can also use as Coloring Pages.

Each of the following six puzzle scenes (2 pages per puzzle) has a highlighted item that you need to search and find. The answers start on page 142.

Don't cheat!

BOOK

HEAVY!!!

LET'S GO!

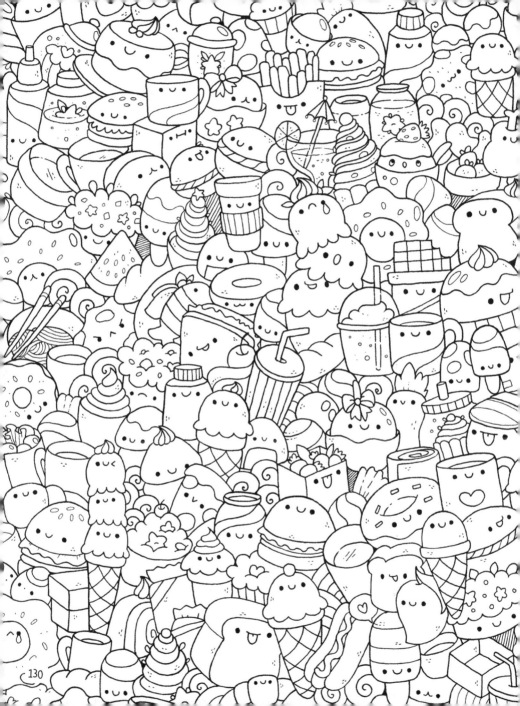

130

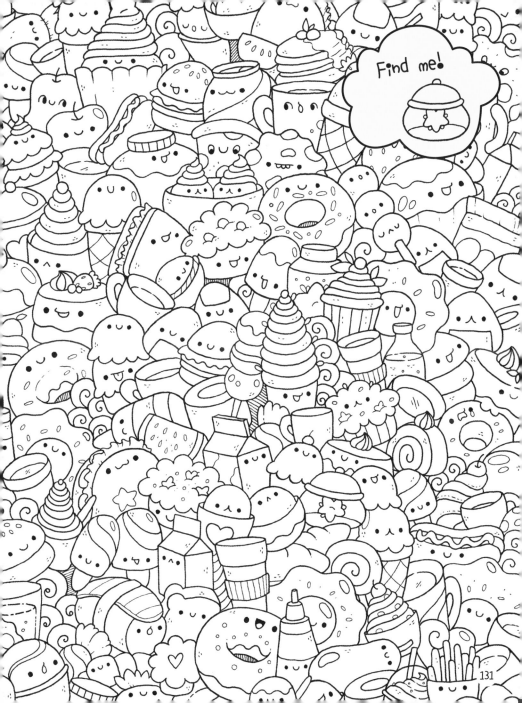

Find me!

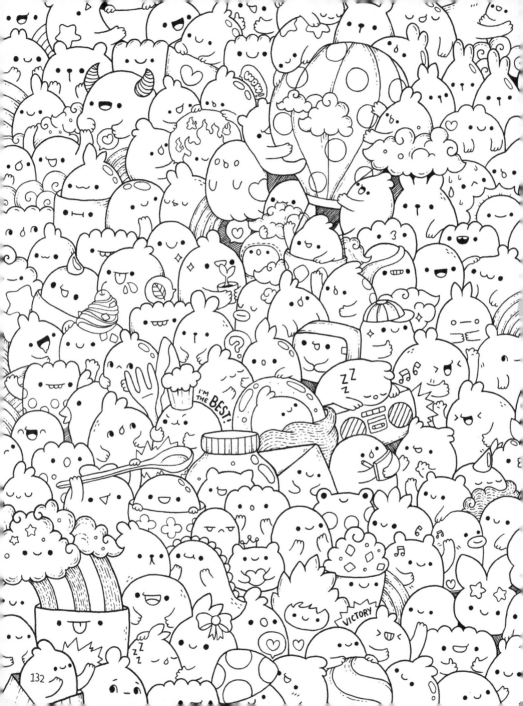

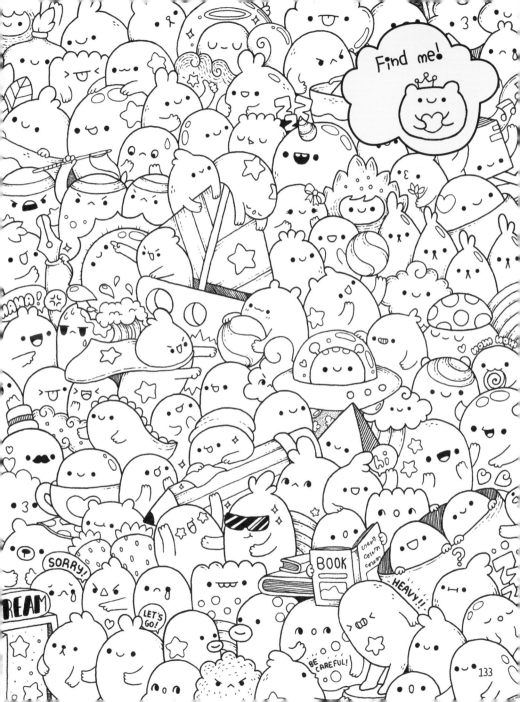

Find me!

133

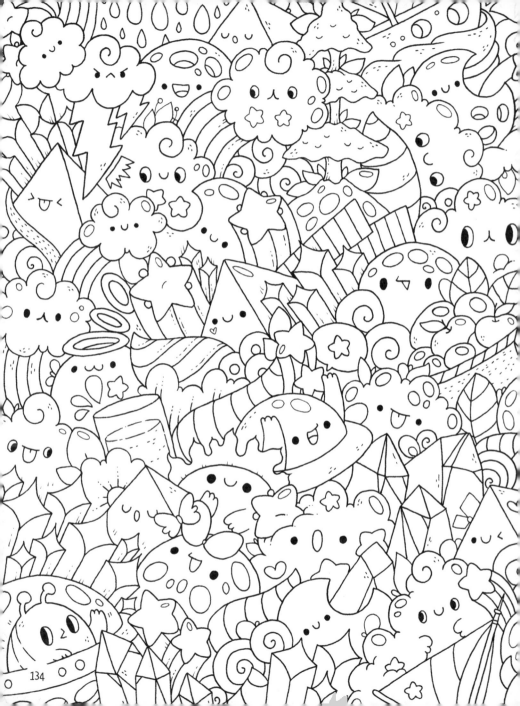

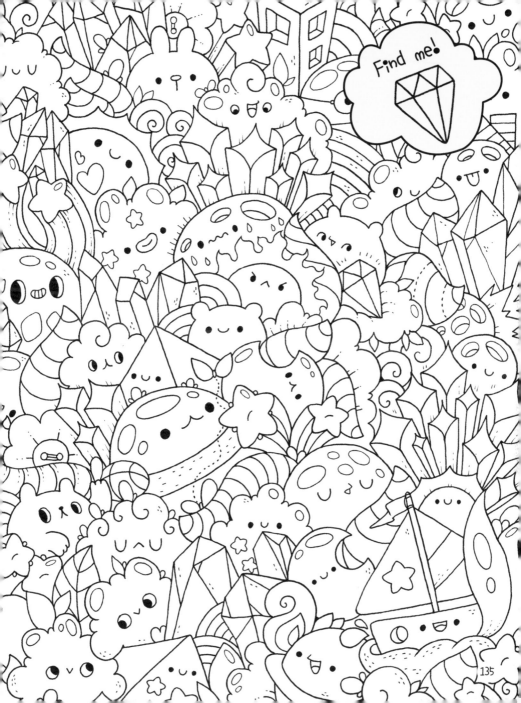

Find me!

135

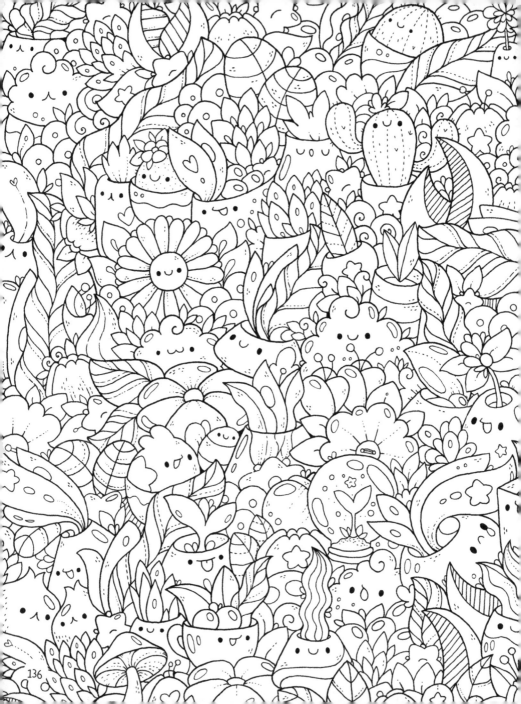

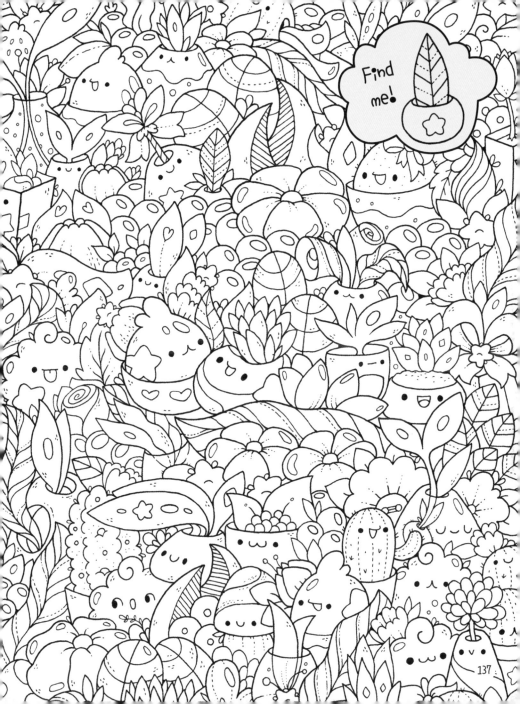

Find me!

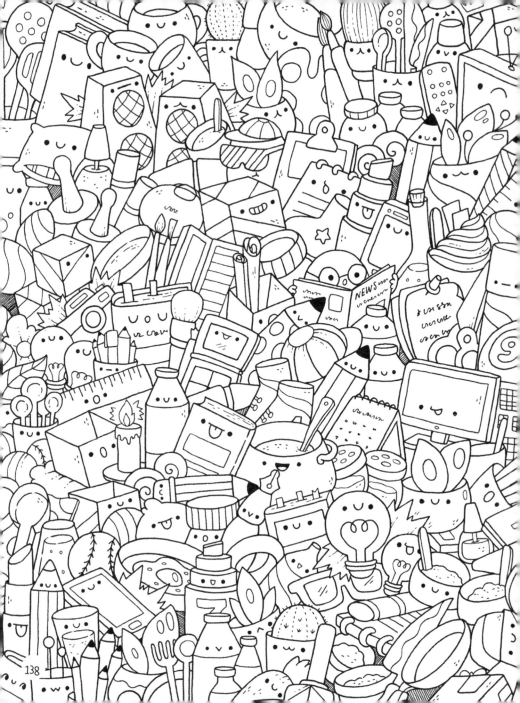

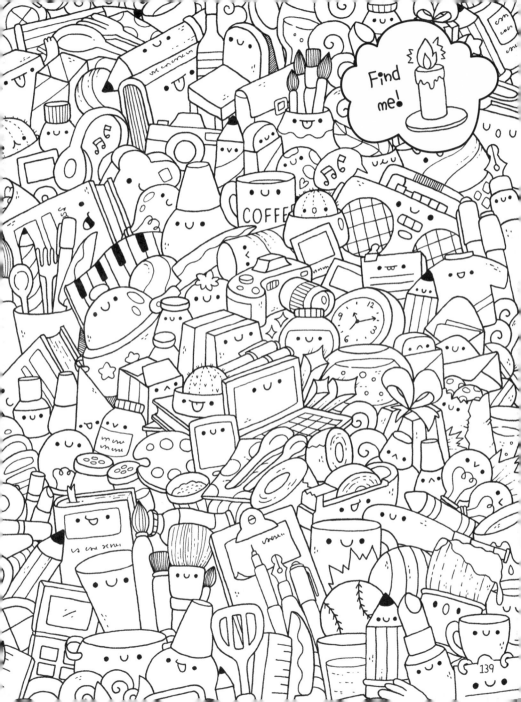

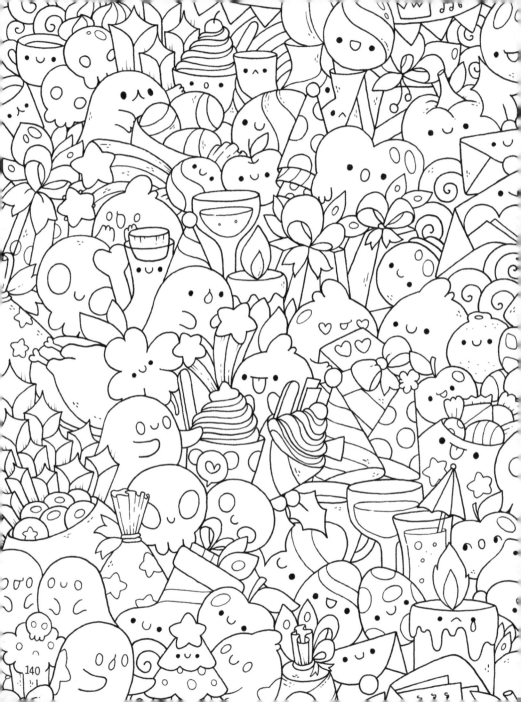

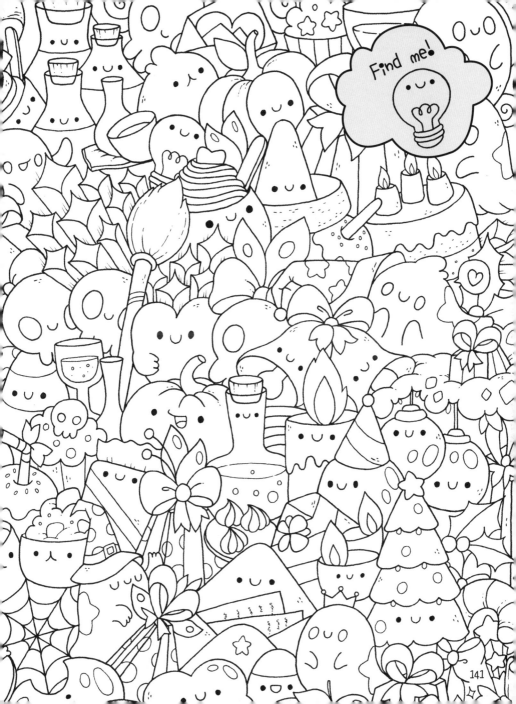

Search-&-Find Puzzle Answers!

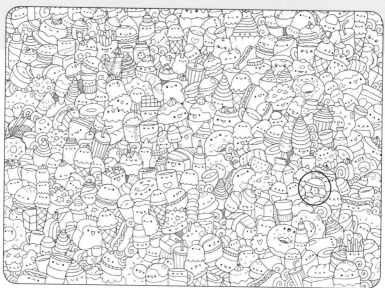

Key for pages 130–131

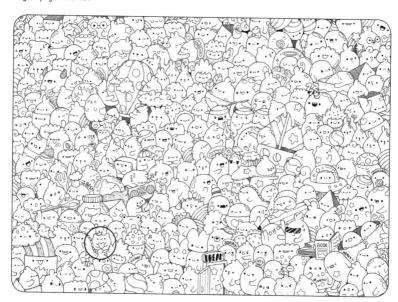

Key for pages 132–133

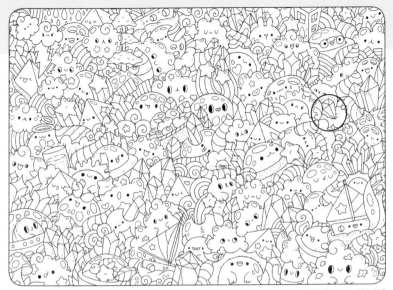

Key for pages 134–135

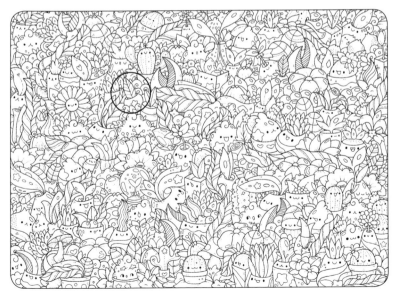

Key for pages 136–137

Search & Find Puzzle Answers 143

Search-&-Find Puzzle Answers!

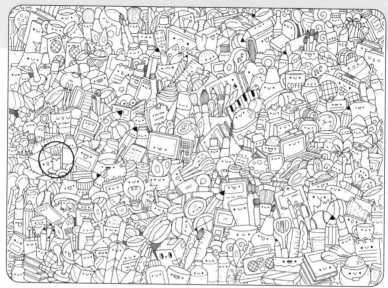

Key for pages 138–139

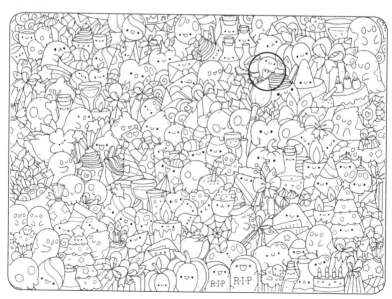

Key for pages 140–141